now is
LOVE

poem & paintings
Cooper Hayes Simmons

VITALITY

buzz, bliss + books

Now Is Love, poem & paintings
Copyright © 2022 by Cooper Hayes Simmons
Published by VITALITY buzz, bliss + books LLC (U.S.A)
vitalitybuzz.org

Cover art by the author.
Cover design by Julie Lucas of withinwonder.com.

ISBN: 978-1-954688-14-8
Library of Congress Control: applied for

in gratitude
to the VATRONS
who pre-ordered
and breathed life into this book

Victoria Arraje, Ronny Beck, Harry Blanton,
Mary Ann Blome, Cheryl Charkins,
Audrey Eyman, Kathleen Hebbeler,
Annette Klein, Nikki Lieberman,
Sidney Lieberman, Lorin Lindner,
Michael Marchal, Michele Mascari,
Khin Win Myat, Tracy Noe, Elizabeth O'Keefe,
Karen Payton, Rick Ramirez, Marty Roberts,
Sarah Roeder, Melissa Rowland,
David Secunda, Brian Shircliff,
Matthew Simmons, Bobby Sparks

Being Love
 be with Love
by compassion
the Light within Love

Love of Light \ to sit aside by candle light…

 safe amidst the darkest night \ secluded within the serendipity of the souls sunlit.

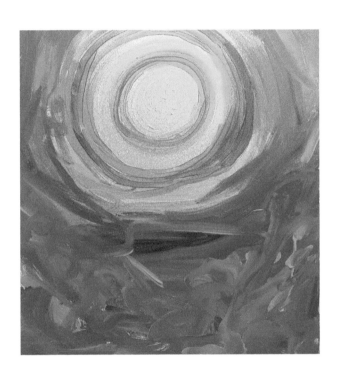

Grassy tides giving way…
to pale canary eyes void of Rage….far from
sight….o' dark night spare those who
genuflect
 towards Light
 Light of Love rekindles souls into embers
of Compassion and Light/ to lead the fire
of Compassion by Night.

sunshine derived... giving way to
unyielding, golden, radiant... Light
 beauty in All...in the tiniest grain of
sand......or the immovable roots of
redwoods

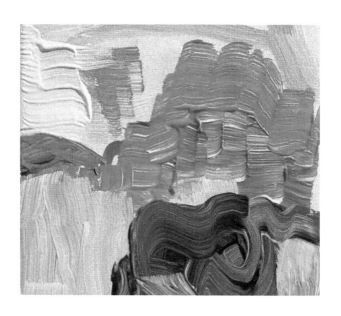

all is well all is beautiful all is Light as
Nature manifests itself every day and night.

Orbs of light in a cosmic dance….
Magentas, crimsons and ochers
in a strip of land
brushed beneath the trees… be one with
the trees for they hear what you see…
see
between the leaves….
Love is One…..Love Always Will Be

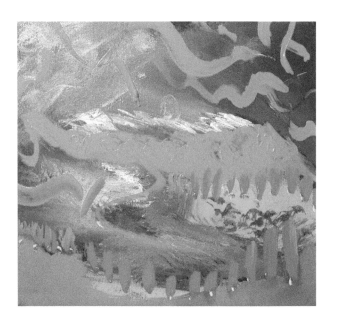

all flows only yet time remains imprinted
with crimsons and pale yellows displaying
Nature's beatific blooms. Cosmic fractals.
Air

yearning to Be free… the wind beckoning
to the
Trees

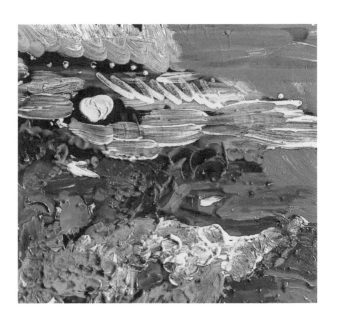

be compassion soul to Souls... to stand until
the Being knows
the Soul flees for it requires the Mind to be at Ease.

Free of unease…despair….. yearning to
Be
with Nature….Alone and Unseen.
 Reassembling the being searching for a
sound…..the bell. Forged of battered
bronze….
in eternal waters….to ring…… ushering in
waves of Peace…

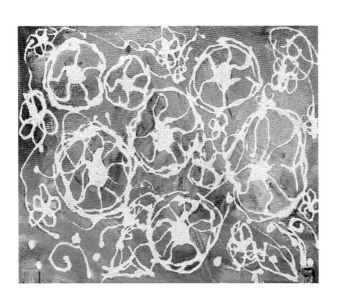

when all Is settled and the mind is
mended.
Love returns… as was always intended.
the scents of pine mixed with myrrh. O
sweet
smells fill the air…..correcting the colors of
hateful air.

Her Light Refracted by Her alone beneath
Cosmic night. Watching stars and galaxies
being
born anew…cascading light obstructs the
view…

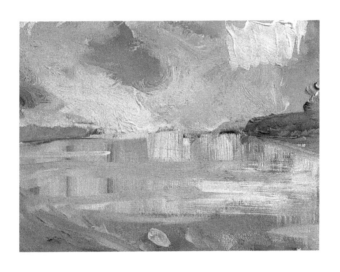

eternity bathing in Cosmic wonders…
amongst
the sea of Loving Compassion

…to be at peace with Her…Mother
Nature…..
for it is she that gave you a Place to BE. for
Love will last for All eternity on all planes
of
existence in equanimity. The iridescent
Leaves

lifting up my Being to be received by the
Light
Light rotating and dancing as it breaks
through
the canopy…. in unison with Nature's
cadence…. all flowing from One into One
back

into the All…. The sky is Love I am Love……
merely a vessel to carry Love and Compassion
into this Plane. // wishing All Beings Peace…….Equanimity, roaming in Love.
amidst the Trees.

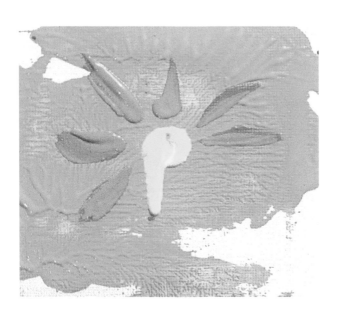

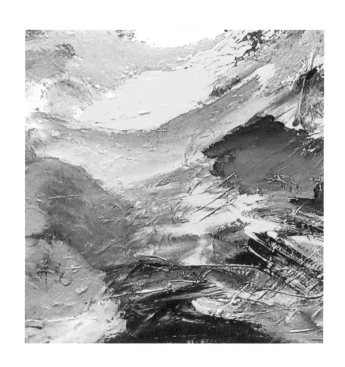

Breathing In Love & more love....ah.....to
sit alongside the River of Time....
 floating by as we delve inside..... to BE
Love/. Now Is Love. Love is Now.
 Changing Hearts alongside Minds....
without
moving using only the Awareness of each
moments inner Shrine.

Unyielding Love and Compassion and
Grace
Love is carried only the divine remains
Let go of anger release fear allowing G-d
to
appear the inner sight breaking way to
Divine
Light. Love, basking in the warmth of Spirit
wading in the communal
Ocean of Love

I am Loving Spirit
I am Loving Spirit
I am Loving Spirit
I am Love. Now is Love.

I am Loving Spirit
 Manifested in the physical plane.
 Create Love in all spaces...
 Peace eternal in all
moments enshrined in
 Love
winds of compassion continue. as the
world
turns no more nations only love in new
spaces

only kindness and Light a new dawn
break
in the bells ring in every town, city and
chapel...
freedom in harmony
compassion over corruption
compassion the call within the wind. to
care
again.

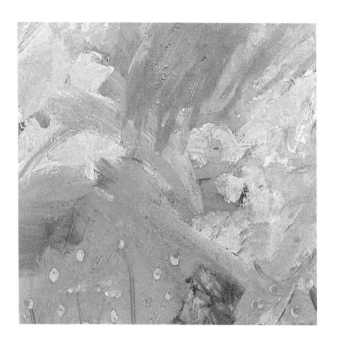

loving-kindness-loving being
 with compassion finding grace in every
spirit and place
 by silent serenity beatific grace.

Love…. Love… love…
I Am Love
I am….. amness… amness is love… listen
to
the inner song of the Heart.

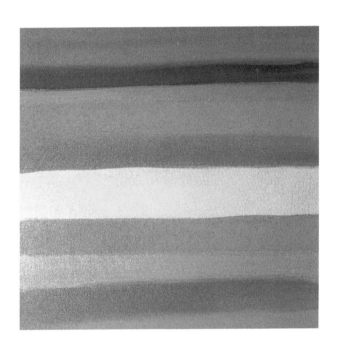

Compassion, empathy and above all
kindness O' radiant lotus unfurling ochre
light
within the soul-cave of the heart
Bestowing Peace eternally

\All beings should see the Love in their
eyes
all people as children of G-d
the soul is Kindness
An eternal river of LOVE

Cooper Hayes Simmons has explored many religious traditions from the inside, especially the meditative traditions within Judaism, Hinduism, Buddhism, and Christianity. He has been influenced profoundly by the San Francisco Beat poets who were bringing forth the wisdom of these ancient traditions in new ways. *Now Is Love* resonates with the love poems of all of these traditions and more, love's permeating invitation in the air, in the breeze for any and all of us to enjoy.

His paintings spring from that same well of wisdom:

"I identify completely with the paint…
I go in with the brush and out with the color."

about VITALITY

VITALITY is a circle of friends welcoming all, awakening each other, and reminding each other that we are Whole. Our affordable self-care programs invite everyone to move, to breathe, to rest, to contemplate, to grow...wherever each person begins their self-care journey, wherever and however they want to become.

vitalitycincinnati.org

VITALITY buzz, bliss + books LLC publishes books & creations from VITALITY's circle of friends to inspire love, creativity, + possibility:

Selected Homilies: allowing life experience to open up the ways and the Word of God by Richard Bollman, S.J.

With You in Our Dreams, a reading and coloring book for all ages by Mike Eck & Claire Long

Midlife Calm: An Alternative to Midlife Crisis by Krista M. Powers

Milford: A poet's life in spiritual retreat by Evan R. Underbrink

The Naked Path of Prophet series by Brian J. Shircliff

vitalitybuzz.org

9 781954 688148